THE
PENCIL
PLAYBOOK

44 Exercises for Mesmerizing, Marking,
and Making Magical Art With Your Pencil

ANA MONTIEL

QUARRY

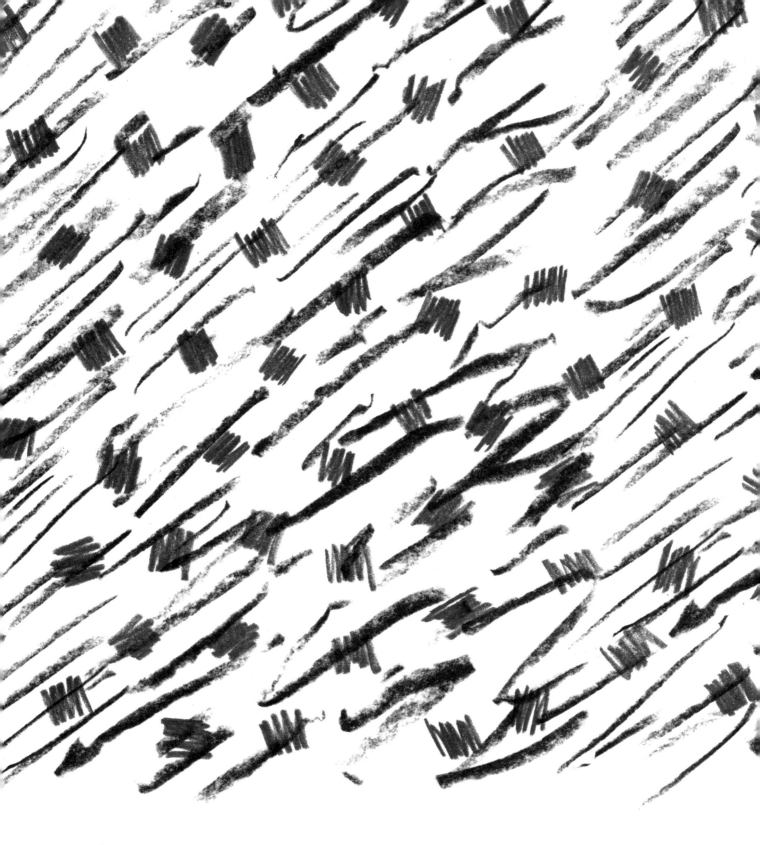

"AN ARTIST MUST BE FREE TO CHOOSE WHAT HE DOES, CERTAINLY, BUT HE MUST ALSO NEVER BE AFRAID TO DO WHAT HE MIGHT CHOOSE."
LANGSTON HUGHES

THE **PENCIL** PLAYBOOK

CONTENTS

Hyd 2018

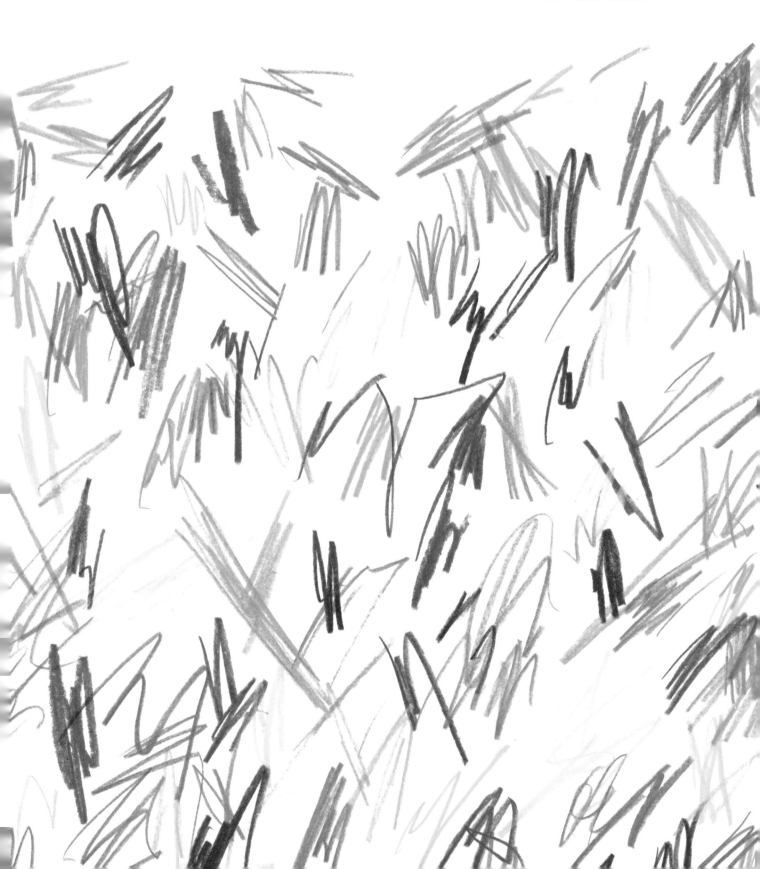

"IF I CREATE FROM THE HEART, NEARLY EVERYTHING WORKS; IF FROM THE HEAD, ALMOST NOTHING." MARC CHAGALL

Thank you for choosing this book. I'm very happy to have you here.

Inside this playbook, you'll find exercises that are intended to work as explorations in various pencil techniques. I provide instructions and tips, but feel free to experiment in different ways and follow your intuition. The key is to have fun with our pastels, pencils, and charcoals!

The artwork doesn't have to look great all the time, nor does it have to be too detailed or representational. What matters is enjoying the creative process and taking incremental steps toward a more colorful life. Creativity has to be free and never is to be judged. Everything has a place in this world, even the things you consider ugly may seem beautiful to another person!

Painting and drawing can be the kinds of activities that help you focus on the present moment and allow you to tap into your inner wisdom to find insight. For me, they are like meditating. When we turn off our rational brain, we can start getting in touch with our wildly creative subconscious mind. This is one of the powers of art.

Be inspired, play, draw—make a mess if you may—clean and repeat. Forever.

Yours in color and shape,

DRAW YOUR INITIAL

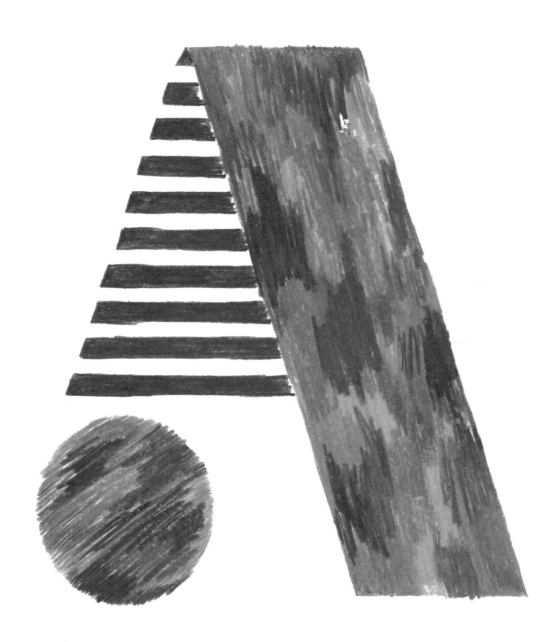

DRAW HERE

Your initial can be drawn in so many ways. It can have flourishes, it can be very simple, it can be thin and delicate, or it can be geometric and bold, as shown here. Make a few tiny sketches trying different styles and choose the one you like the best. Outline it with care and fill it with any motifs and textures you like. Color freely *et voilà*!

TIP: EXPLORE ALL KINDS OF ORGANIC AND REPRESENTATIONAL ELEMENTS AS PART OF YOUR INITIAL. THE ONLY IMPORTANT THING IS TO KEEP THE ORIGINAL LETTER SHAPE YOU OUTLINED—THE REST IS FREESTYLE!

MASK COLLECTION

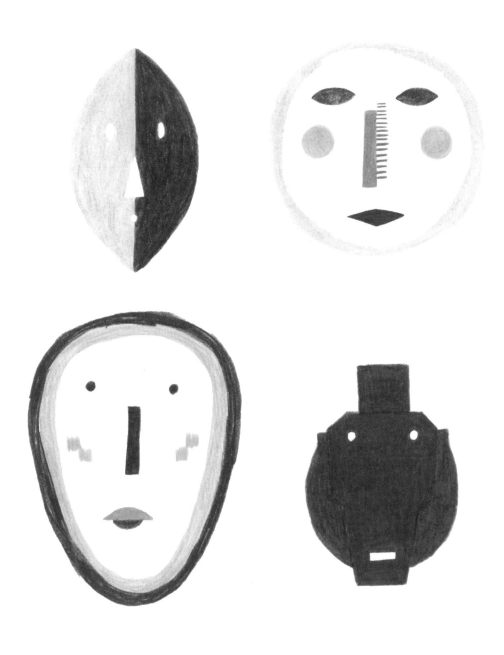

Synthesizing faces to create masks can be fun. Be as detailed or minimal as you like, and, for inspiration, you can always research a bit of African tribal adornment. Bold and earth tones will work well for this exercise, but feel free to try any palette!

TIP: DON'T BE AFRAID OF USING UNCOMMON SHAPES FOR YOUR MASKS. AS LONG AS THEY HAVE A COUPLE OF FACIAL FEATURES, SUCH AS EYES OR A MOUTH, THEY WILL LOOK LIKE MASKS.

REARRANGEMENT

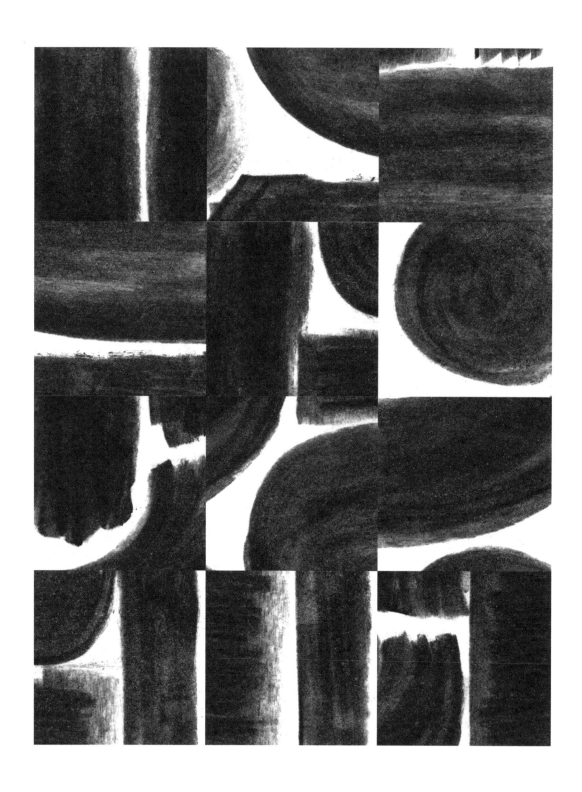

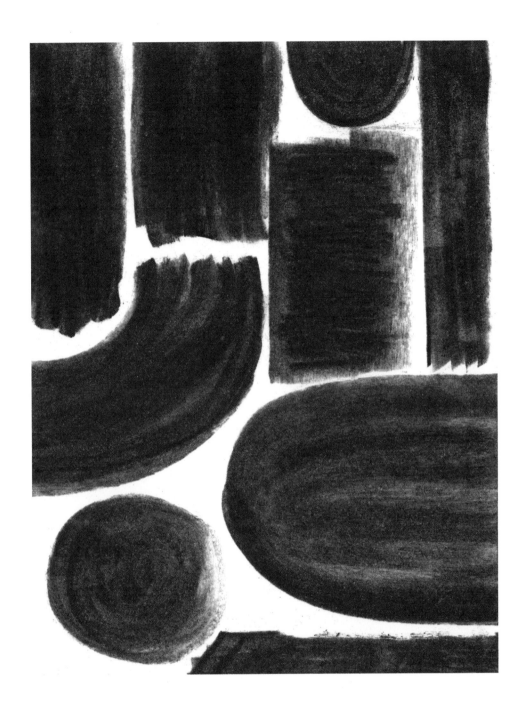

Make a drawing with charcoal using the side of the charcoal for a wider stroke. Then divide the paper into equally sized pieces and rearrange them randomly. Glue them to a new piece of paper. The modules can be any shape as long as they fit together.

TIP: FINISH YOUR DRAWING WITH FIXATIVE AS SOON AS YOU ARE DONE WITH IT. CHARCOAL CAN BE VERY MESSY! IF YOU DON'T HAVE A DRAWING FIXATIVE, YOU CAN USE HAIRSPRAY.

GRAPHIC LEAVES

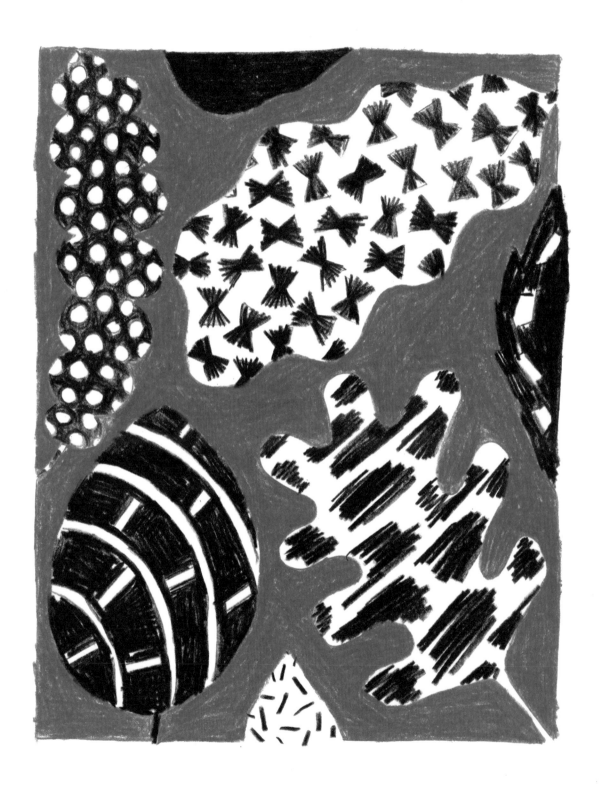

DRAW HERE

Make some shapes and fill them with black and white textures for a bold and graphic look. You can outline your drawing directly with the pencil that you'll be using for the background. Explore different colors and shapes—the possibilities are endless!

TIP: FOR A SHARPER LOOK, YOU COULD ALSO DO THIS EXERCISE AS A COLLAGE. START BY DRAWING DIFFERENT TEXTURES ON PIECES OF PAPER, CUT THEM INTO LEAF SHAPES, AND THEN ARRANGE THEM ON A PIECE OF COLORED PAPER.

BUILDINGS

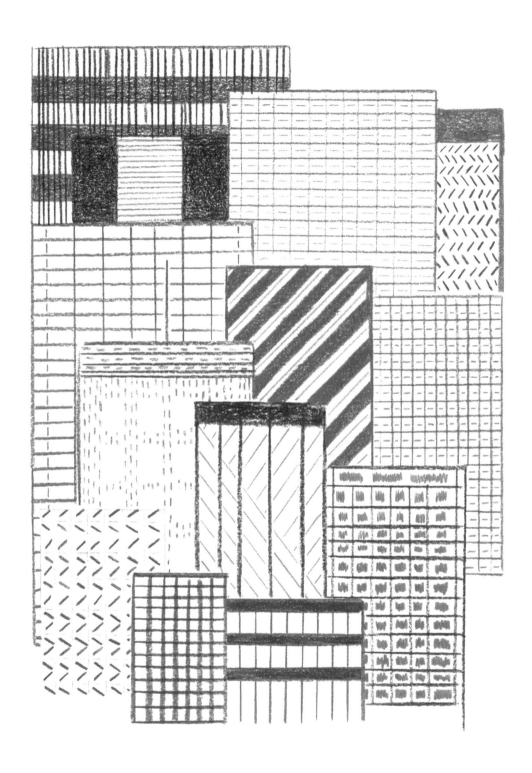

Outline different buildings with a 2B pencil to create a skyline composition. A ruler always helps to keep things straight and tidy. Add lines and patterns to imply architectural details and windows. Use a restricted palette for a cohesive overall look.

TIP: SKIP THE RULER PART AND GO ALL FREEHAND TO ACHIEVE A MORE SPONTANEOUS LOOK. YOU COULD ALSO ADD SPECIFIC ARCHITECTURAL ORNAMENTS FOR A MORE REALISTIC SCENE.

NEW WAVE MANDALA

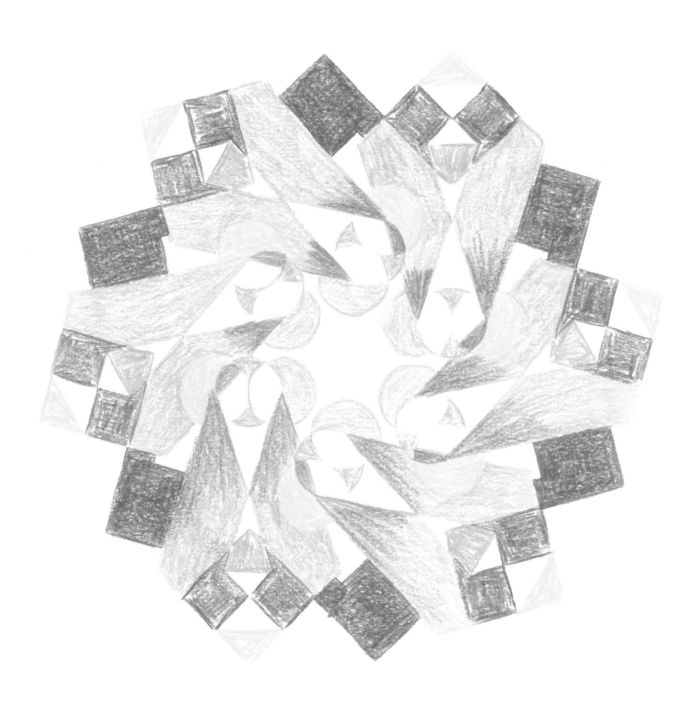

DRAW
HERE

Use a pencil to sketch out a large asterisk shape. This will form the axes of your mandala. Draw a few shapes along one of the axes, either freehand or with the help of a ruler or template. Copy the shapes on the other axes to create the repeating pattern.

TIP: REPLICATING THE SAME HUES ON THE DIFFERENT AXES WILL HELP THE MANDALA ACHIEVE A RHYTHMIC, REPETITIVE FLOW. FEEL FREE TO USE DIFFERENT COLORS ON THE SAME AREA FOR A GRADIENT EFFECT.

STRONG MARKS

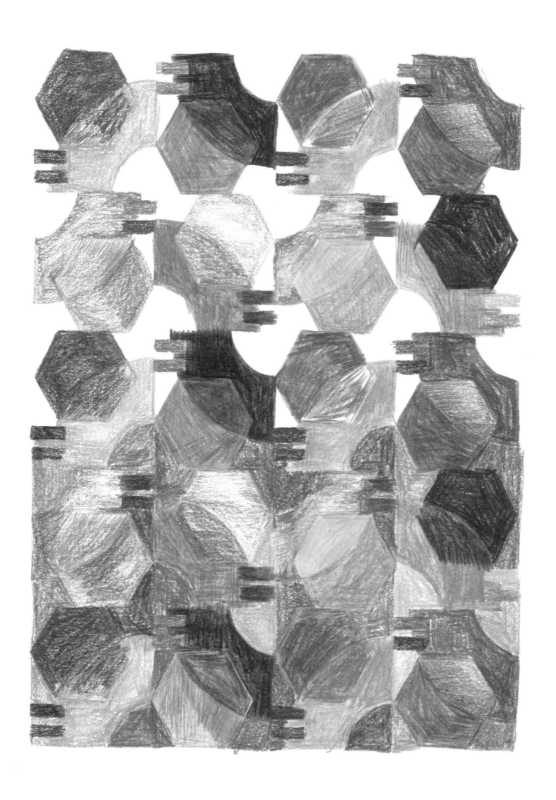

This composition is based upon the repetition of a module. You can draw a grid on the paper and replicate the repeat piece. Alternatively, you can cut a template on cardboard and trace it on the grid instead of drawing and measuring it. Go wild applying plenty of pressure with the pencils, but be careful not to break them!

TIP: I USED A WARM COLOR PALETTE TO UNIFY THE PATTERN, BUT YOU CAN USE ANY OTHER PALETTE. ALSO, YOU CAN TRY DIFFERENT COLORS ON TOP OF EACH OTHER TO GIVE THE DRAWING A MULTI-DIMENSIONAL FEEL.

SGRAFFITO

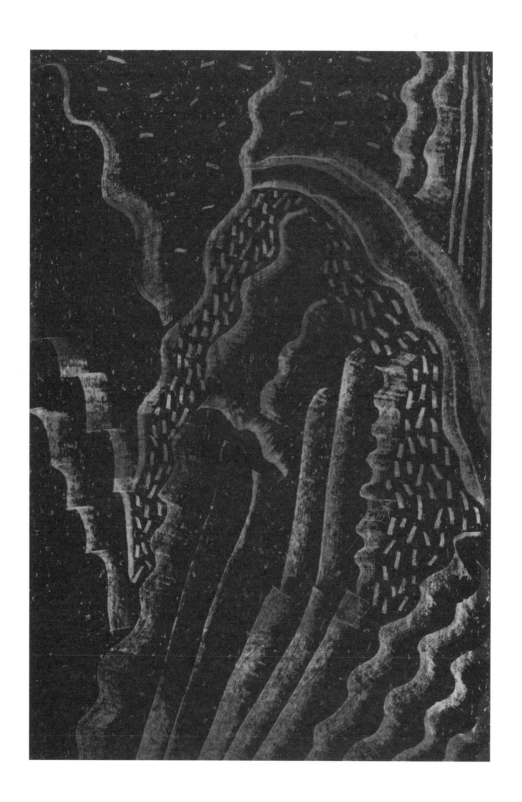

Using a wax pastel crayon, first cover the entire paper with different colors—the brighter, the better. Apply a layer of dark color on top, covering the bright colors completely. Then start drawing by gently scratching away the dark surface with a pin or a knife to make a pattern.

TIP: TRY MANY DIFFERENT TOOLS TO REMOVE THE BLACK COAT OF WAX PASTEL. EACH OF THEM WILL GIVE YOU A DIFFERENT TYPE OF MARK. FOR EXAMPLE, TRY SCRAPING YOUR PATTERN WITH A SMALL METAL SPOON.

TWIN BOOTS

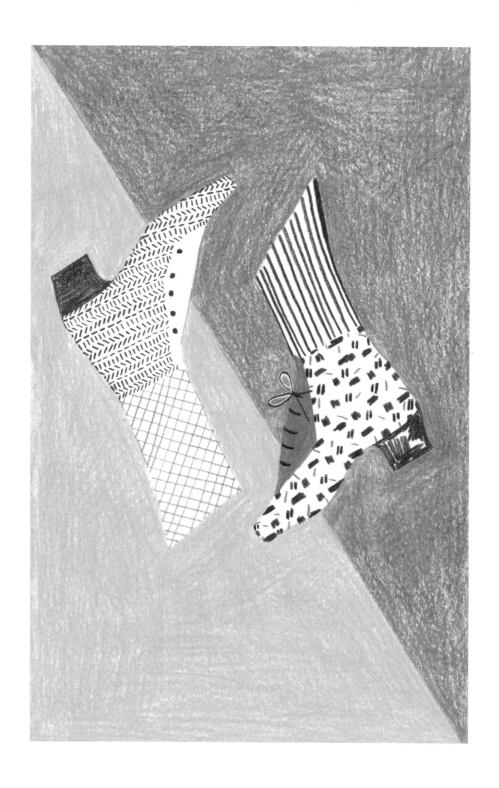

DRAW
HERE

Draw one of the boots and then use tracing paper and a soft graphite pencil to copy it. Flip the tracing paper over and rub it to transfer the soft pencil marks to the page and form the second boot.

TIP: THE IDEA HERE IS TO PLAY WITH SYMMETRY BY REPEATING AN ELEMENT TWICE (LIKE THE DRAWING OF A BOOT), BUT USING DIFFERENT TEXTURES TO DIFFERENTIATE THEM. FEEL FREE TO EXPERIMENT WITH VARIOUS STYLES.

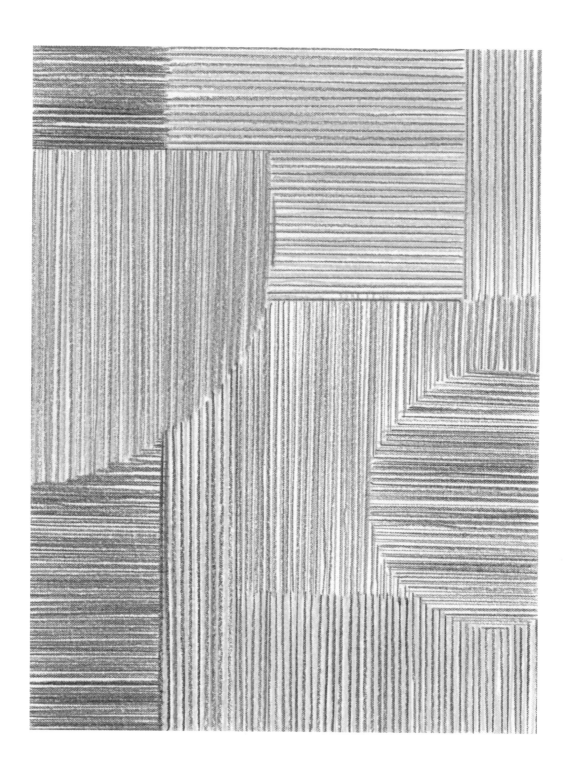

DRAW HERE

Outline some shapes and start filling in the different areas with relatively even lines. Make lines using one color and then use a different color in the spaces between the previous lines. For an optical effect, try making the alternate lines with complementary colors. When seen from a distance, this combination will look pretty neutral.

TIP: A 90- AND 60-DEGREE SQUARE SET HELPS MAKE PARALLEL LINES EASILY. JUST PLACE THEM TOGETHER AND SLIDE THE ONE YOU ARE USING SLIGHTLY AGAINST THE OTHER TO MAKE THE LINES.

CONFETTI ARCHITECTURE

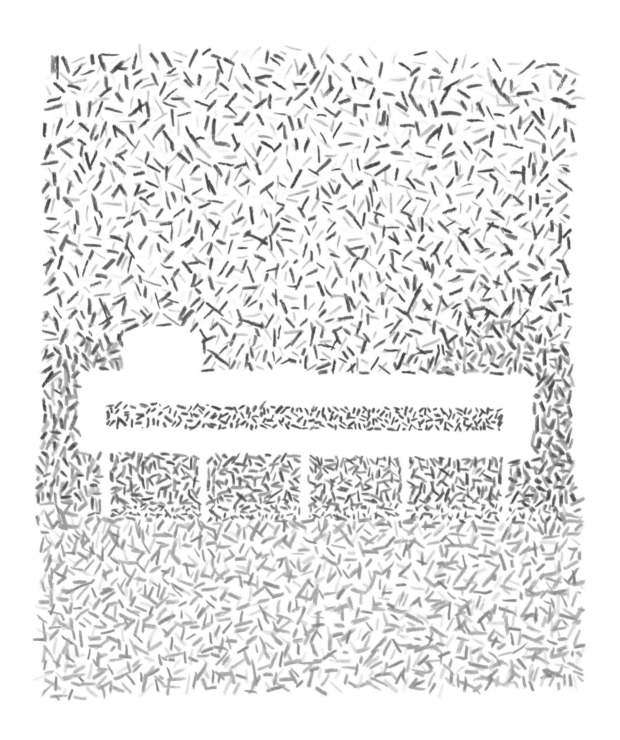

Outline Le Corbusier's Ville Savoye with a medium graphite pencil and start filling in the areas with small marks. Use as many colors as you like to give the artwork depth. The use of negative (blank) space is key when playing with contrast. When done, you can carefully erase the original pencil outline for a cleaner finish.

TIP: ROTATING THE COLOR PENCILS WHILE YOU USE THEM WILL KEEP THEM SHARPER FOR LONGER AND ALLOW FOR MORE EVEN MARKS.

STEREO PENCIL

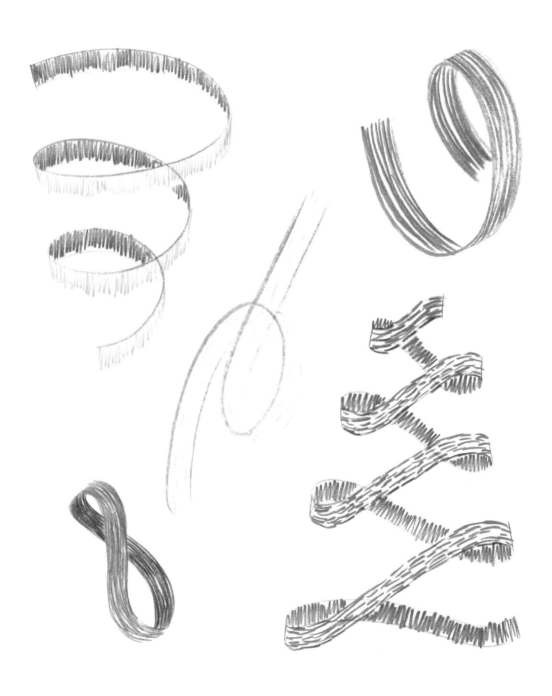

Pick a couple of pencils and tie them together with a rubber band or string. Draw with them so that you get two lines flowing at the same time. Experiment with different colors and moves. You can add textures or details between the two main lines.

TIP: FEEL FREE TO USE MORE THAN TWO PENCILS AT THE SAME TIME TO DRAW—IT CAN GIVE YOU A COLOR SYMPHONY! JUST BE SURE THAT THE RUBBER BAND IS TIGHT AND YOUR PENCILS ARE ALIGNED.

BUILDING UP

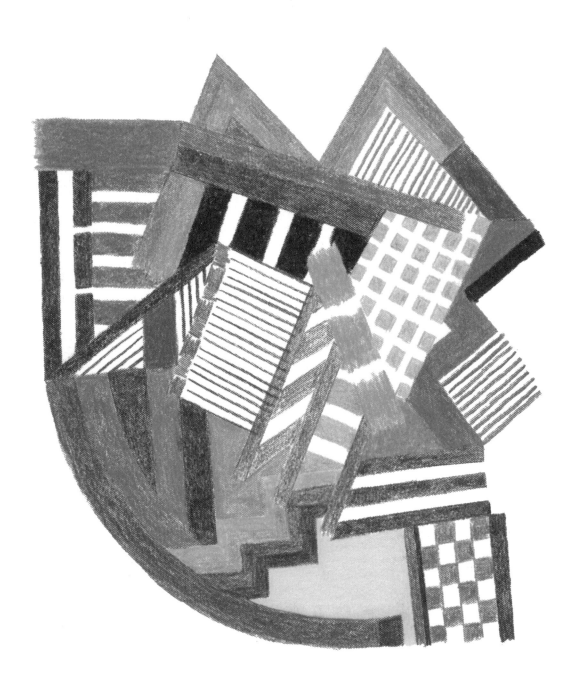

Start drawing the first of the shapes on the center of the paper and then start building up the rest of the pieces around that first one. Let your composition grow organically. Feel free to use a wider range of colors or just one if you prefer.

TIP: THIS IS A GOOD WAY TO START A SIMPLE, NON-REPEATING PATTERN. THE ONLY THING YOU NEED TO DO IS KEEP DRAWING UNTIL YOU FILL THE PAPER COMPLETELY. TRY AVOIDING STRAIGHT ANGLES TO MAKE IT LOOK MORE DYNAMIC.

WILD STROKES

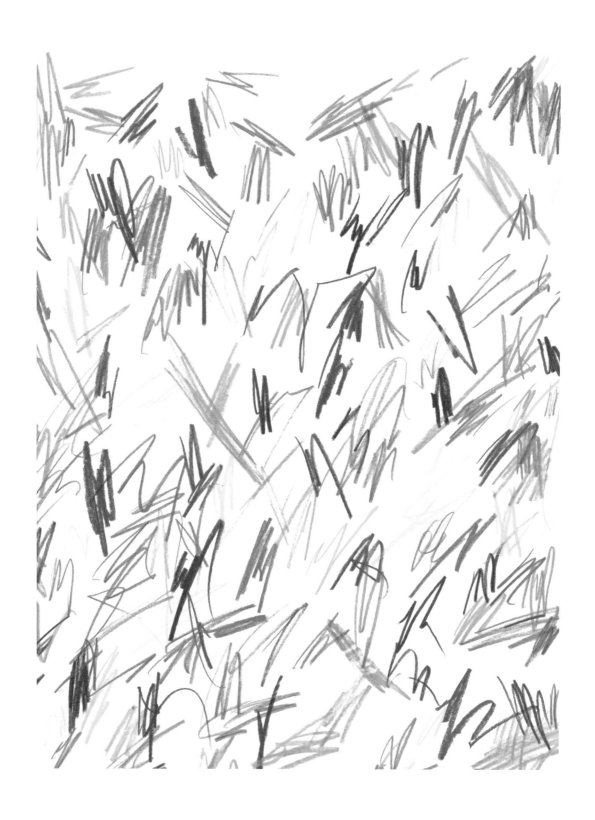

Connect with your inner child and start making random marks on a piece of paper. The marks can be bold and wild if you want or tiny and delicate for a more textured look. Have fun and don't be afraid to make a mess. Sometimes messy is fun!

TIP: YOU CAN MAKE MANY MARKS IN DIFFERENT PLACES WHENEVER YOU PICK A NEW COLOR. THIS WAY, YOUR PROCESS WILL HAVE FEWER INTERRUPTIONS AND BE MORE FLUID AS YOU SWITCH BETWEEN COLORS.

A SONG

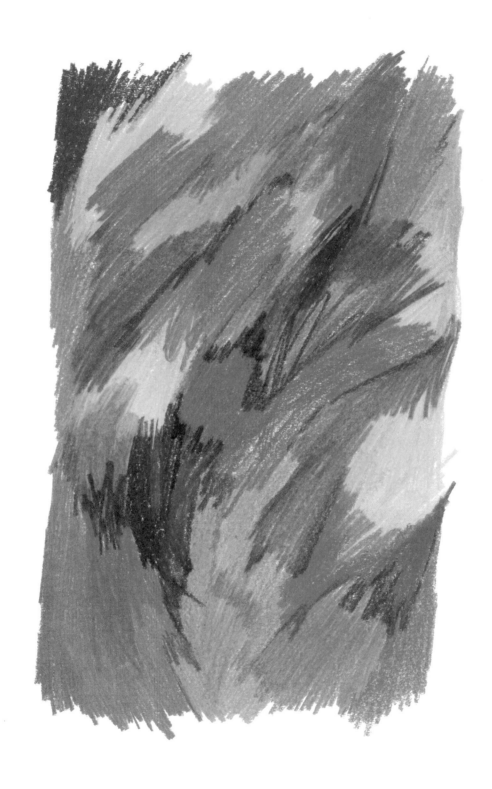

DRAW
HERE

Grab your pencils, play a song that you love, and start drawing as automatically as you can. Don't think, just go with the melody. You can go representational if you want or all abstract. Don't judge—just draw. This artwork was done while listening to "Faking Jazz Together" by Connan Mockasin.

TIP: SOMETIMES MUSIC CAN BE TOO ETHEREAL TO BE REPRESENTED IN A FIGURATIVE WAY, BUT THIS SHOULDN'T BE A PROBLEM. EMBRACE ITS ABSTRACTION AND LET YOURSELF GO.

ARCHITECTURAL CODES

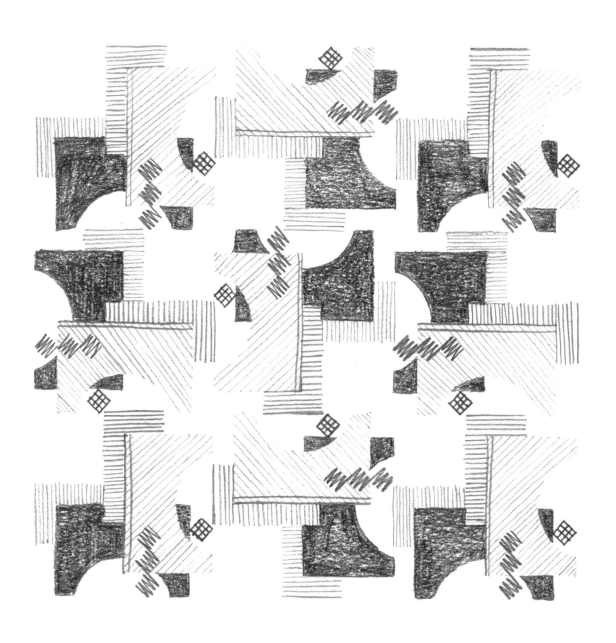

For this drawing, use 3B and 7B pencils. Try a softer pencil (7B) to make the rich, dark areas. Harder pencils will give you a cleaner drawing. Create the structure by positioning some simple stencil shapes made from thin cardboard on the paper and later fill in those areas with different pencils and textures.

TIP: TO KEEP YOUR ARTWORK CLEAN AND TIDY, REST THE HAND YOU ARE DRAWING WITH ON TOP OF A CLEAN PIECE OF PAPER. THIS WAY, YOU WON'T SMUDGE YOUR WORK.

BLENDING

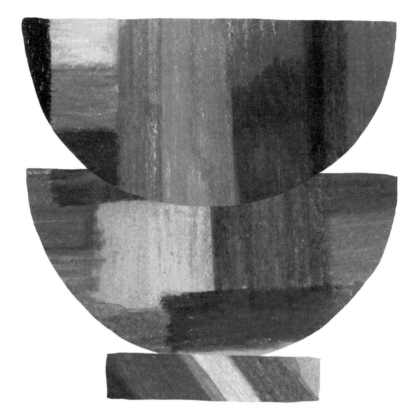

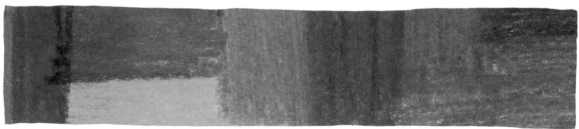

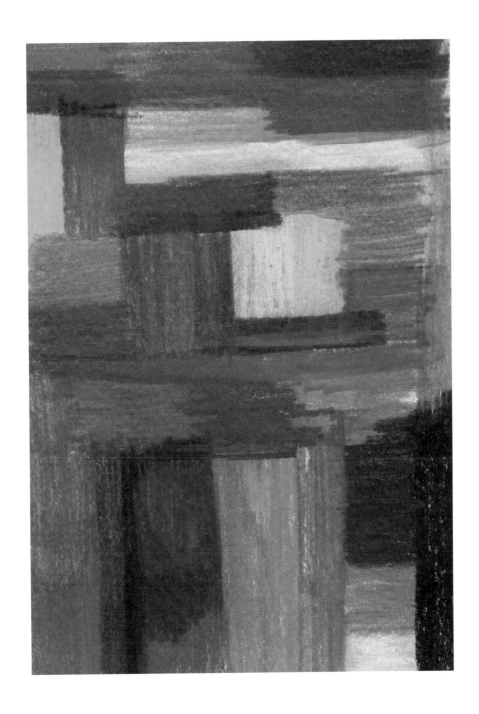

There are products on the market for blending color pencils. They can make your artwork look soft and smooth and it will look like a painting. The one used for this drawing is called Zest-It Pencil Blend. It is a nontoxic liquid and works pretty well.

TIP: FOR A SHARPER LOOK, CUT AND COLLAGE THE BLENDED COLOR SHEET. FEEL FREE TO OMIT THIS STEP AND TRY THIS EXERCISE DRAWING DIRECTLY ON THE PAPER INSTEAD OF CUTTING, ARRANGING, AND PASTING ITS PIECES.

ORGANIC LINES

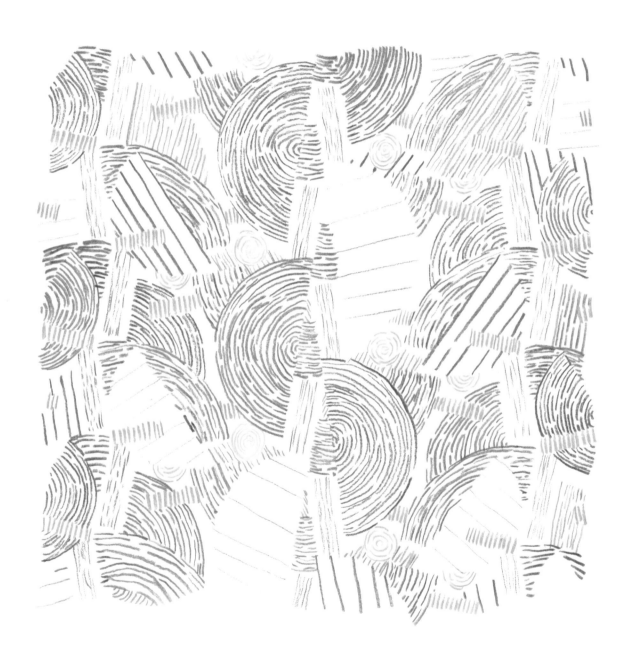

To build the structure that you'll later fill with colored lines, trace some simple geometric shapes with a template or stencil. Arrange the shapes in different angles and positions and start filling the shapes with all kinds of lines. Irregular lines will give your work an organic look but also try thicker, messier, or tidier ones—there are so many possibilities!

TIP: TO IMPROVE YOUR PENCILS' LONGEVITY, DON'T SHARPEN THEM TOO MUCH WITH THE SHARPENER. TRY RUBBING THEIR TIPS AGAINST SANDPAPER OR LIGHTLY SHARPENING THEM WITH A CRAFT KNIFE. THIS WAY THEY WILL LAST LONGER.

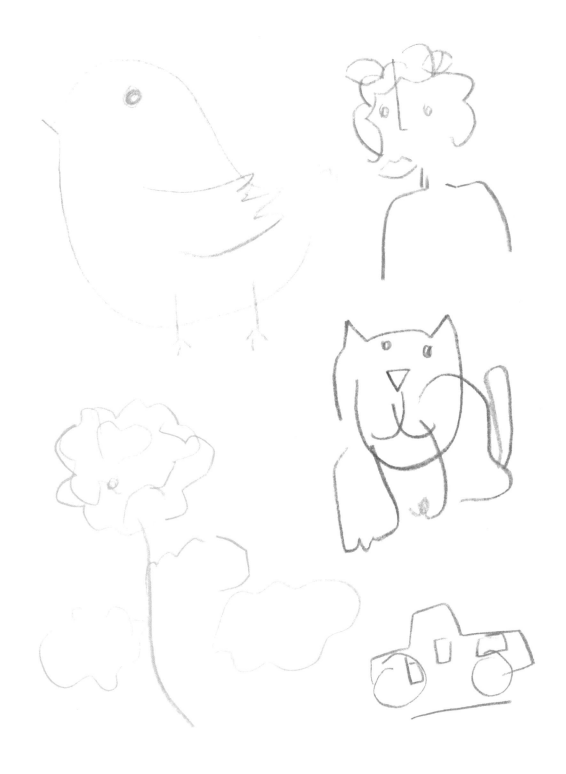

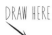

DRAW HERE

Drawing with your eyes closed can be one of the most fun and surprising things you can do with pencil and paper. Picture something in your mind. Close your eyes and draw it from beginning to end without peeking. This will give your artwork raw and unexpected details and keep you from judging it while it is in process.

TIP: DRAW FAST AND WITHOUT THINKING. THESE KINDS OF DRAWINGS WORK BETTER IF THEY ARE SPONTANEOUS. DISTRACT YOURSELF WITH SOME MUSIC THAT YOU LIKE, CLOSE YOUR EYES, AND GO FOR IT!

DELFT PLATES

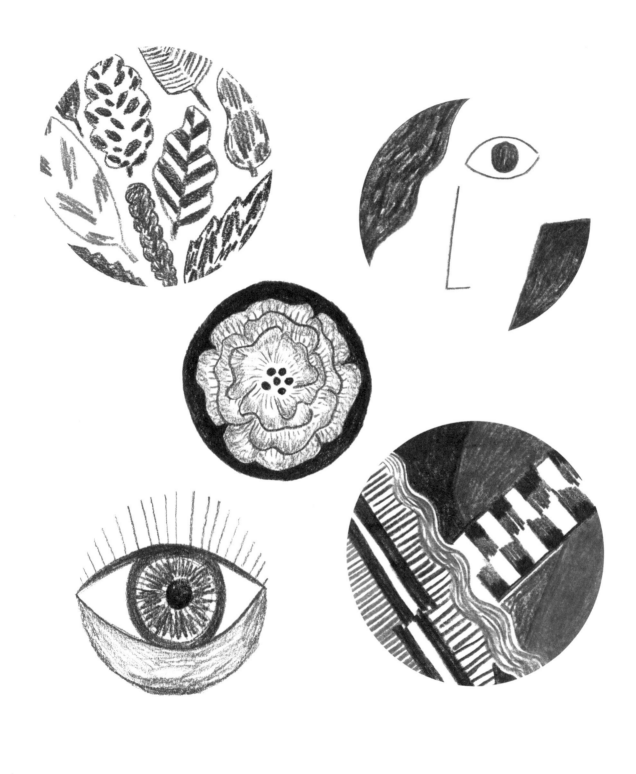

DRAW HERE

Have fun planning an imaginary Delft porcelain set. The only restriction for this is the color palette. Try keeping it around Delft's signature style deep blue hues. Sketch and plan as many as you want. They can be as subtle or as bold as you like.

TIP: IF YOU ARE USING WATER-SOLUBLE PENCILS, TRY APPLYING WATER WITH A BRUSH TO SOME AREAS TO INTENSIFY THE BLUE HUES.

FROM ABOVE

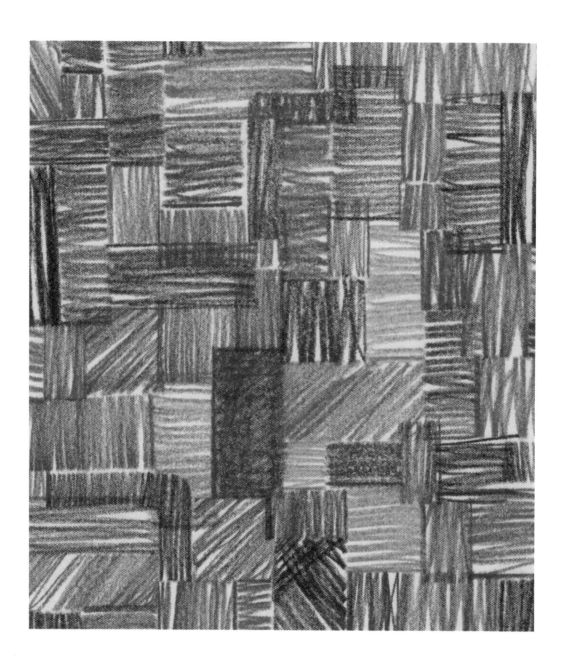

DRAW HERE

The world from above is such a wonderful thing. It can be graphic, organic, and abstract at the same time. Visit Google Maps and try representing a terrain area that you like, such as patches of agricultural land (like mine), mountains, or anything that captures your attention. Free it from representational color and use whatever hues you fancy.

TIP: IF ANY OF YOUR WATER-SOLUBLE PENCIL TIPS BREAK, KEEP THE TIPS AND DISSOLVE THEM AFTERWARD IN A BIT OF WATER. THAT WAY, YOU'LL HAVE LIQUID WATERCOLOR FOR FUTURE EXPERIMENTS!

MIX AND MATCH TILES

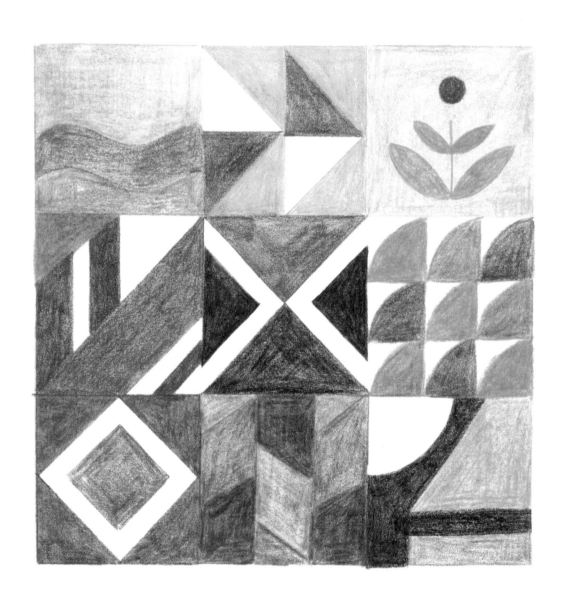

Make a grid and decorate each one of the squares in a different style to give the artwork a mix-and-match vibe. You can be very geometric or fully representational. Also you can try unifying all the tiles using the same colors for all of them.

TIP: YOU CAN MAKE A MODULAR REPEAT PATTERN FROM THIS EXERCISE. CHOOSE WHERE AND HOW THE PIECES ARE GOING TO REPEAT AND PLAY WITH THE COMPOSITION'S RHYTHM.

RAINBOW STROKES

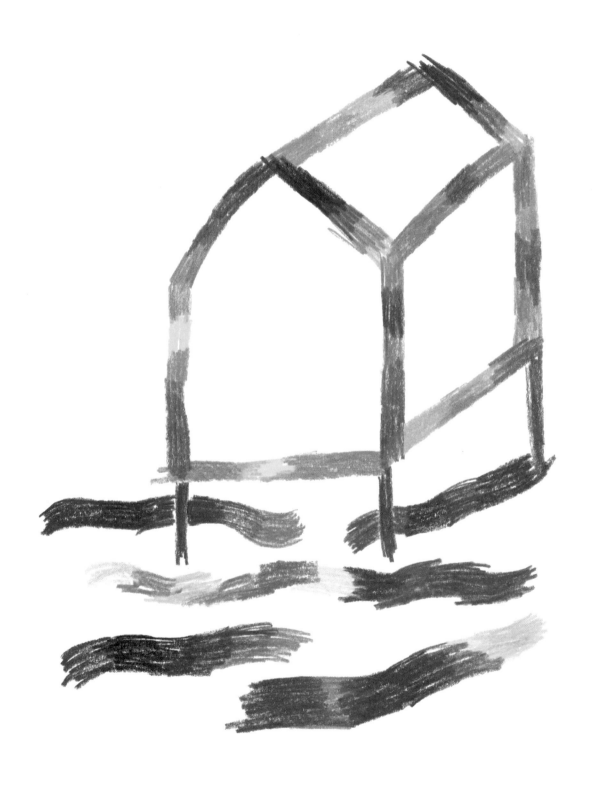

DRAW HERE

A "line drawing" doesn't really have to be done with the average lines. For this one, use different pencil shades side by side to give it a gradient look, but you can also experiment and make your personalized stokes with different styles and techniques.

TIP: IT CAN BE HELPFUL TO OUTLINE YOUR DRAWING'S STRUCTURE SOFTLY WITH PENCIL IN A VERY SIMPLE WAY AND THEN DRAW ON TOP OF IT WITH YOUR FREESTYLE STROKES.

MACRO TEXTURES

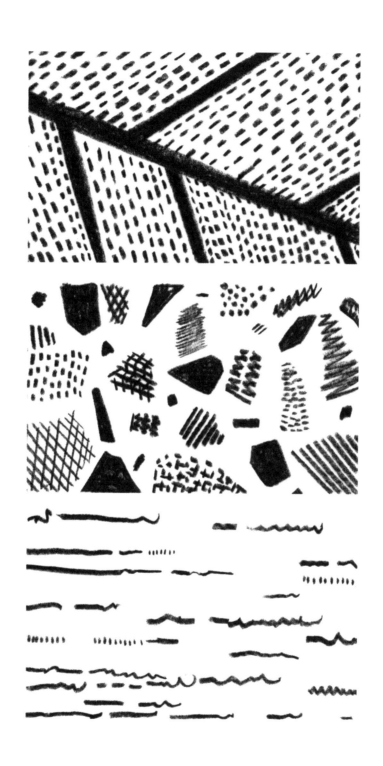

DRAW HERE

Paying close attention to every detail that surrounds you will help you understand and draw the world better. The next time you take a walk, notice the patterns on building materials, the texture on the bark of a tree, the fractals in greenery, and so on. The samples opposite are just a few ideas. The macro world is rich and full of inspiration!

TIP: TAKE PLENTY OF PICTURES ON YOUR WALKS AND LATER TRY REINTERPRETING THE MACRO ONES WITH YOUR DRAWINGS. THIS EXERCISE WILL HELP YOU TO SEE YOUR SURROUNDINGS IN MUCH MORE DETAIL.

DIFFERENT TECHNIQUES

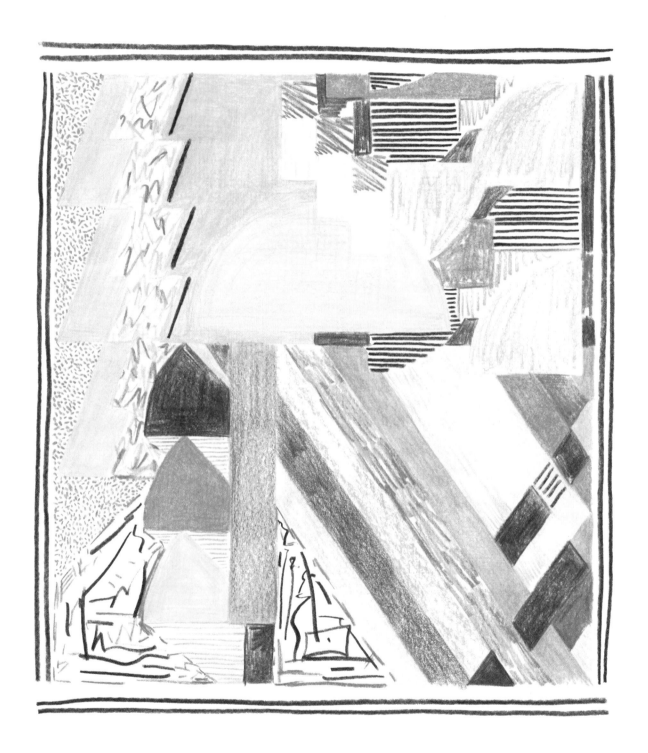

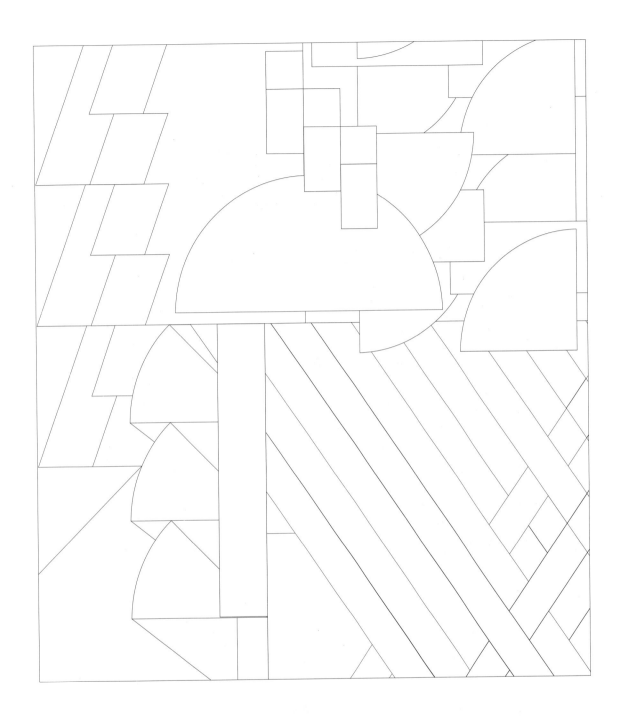

Draw the structure for this exercise with pencil on a blank piece of paper and then place tracing paper on top. This allows you to color in the structure on the tracing paper without having the outlines be part of the final artwork. Cartridge paper can also work as the top layer.

TIP: YOU CAN USE AS MANY TECHNIQUES AS YOU WANT ON A SINGLE ARTWORK. TRY MESSY ONES AND TIDY ONES SIDE BY SIDE TO PLAY WITH CONTRAST. ALSO, BE OPEN TO USE PALE AND MUTED COLORS TOGETHER WITH DARK HUES.

ERASING SHIELD

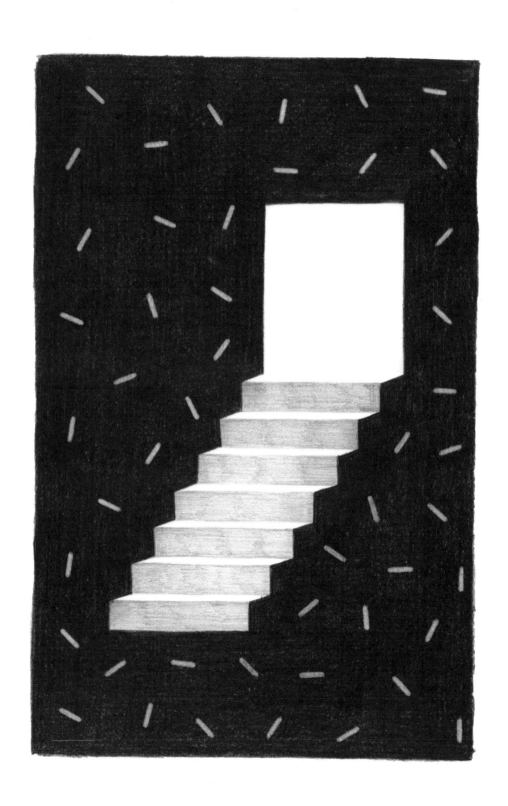

Outline your drawing softly with a 2B or similar pencil. When working with pencil, graphite, or charcoal, always start with the lighter areas and build up and darken them from there. Use an erasing shield as if it was a stencil to remove graphite in some areas and create a pattern or motif in the composition.

TIP: TRY USING THE ERASING SHIELD IN THE OPPOSITE WAY, AS A STENCIL TO APPLY GRAPHITE OR PENCIL WITH. THIS WAY, YOU'LL GET A LIGHT BACKGROUND AND A DARK MOTIF.

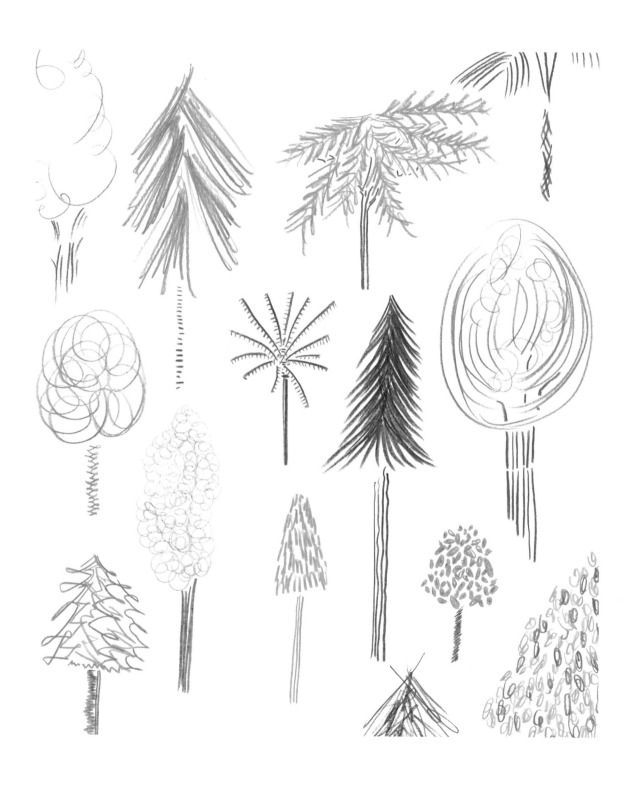

Trees can be as complex or schematic as you want. For this exercise, we are going to explore the latter. Try representing a tree with just a few strokes, as messy or random as you like. You can try scribbling a bit, doodling, or simply outlining.

TIP: BE AS ABSTRACT AS YOU LIKE. AS LONG AS YOU STAY ON THE "TYPICAL TREE" COLOR PALETTE, THE MOTIFS WILL KEEP LOOKING LIKE TREES EVEN THOUGH THEY MAY BE ONLY A FEW MARKS.

SEASONS

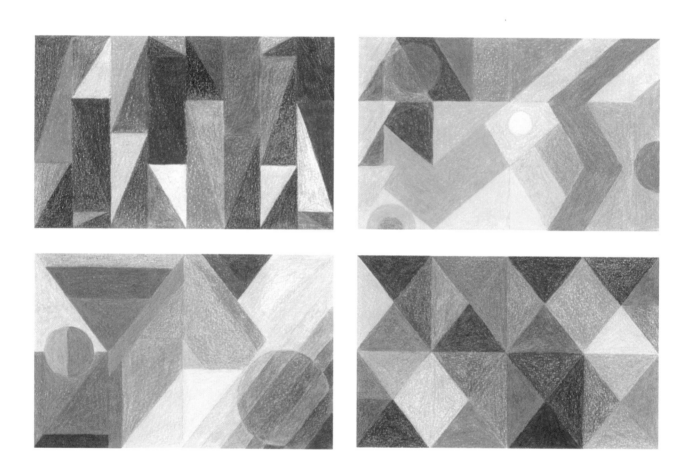

DRAW
HERE

The seasons can be represented in many different ways. For this exercise, you can select a single color to represent each season, draw your favorite things associated with each one, or even make a lettering piece with each season's name. Come up with one that resonates with you and start your seasonal homage.

TIP: TRY COMING UP WITH PERSONAL SYMBOLS THAT YOU FEEL REPRESENT EACH SEASON. FOR EXAMPLE, A SHAPE AND COLOR COMBINATION MAY REMIND YOU OF A FAVORITE SEASONAL FRUIT, A PLACE, OR A HOLIDAY DECORATION.

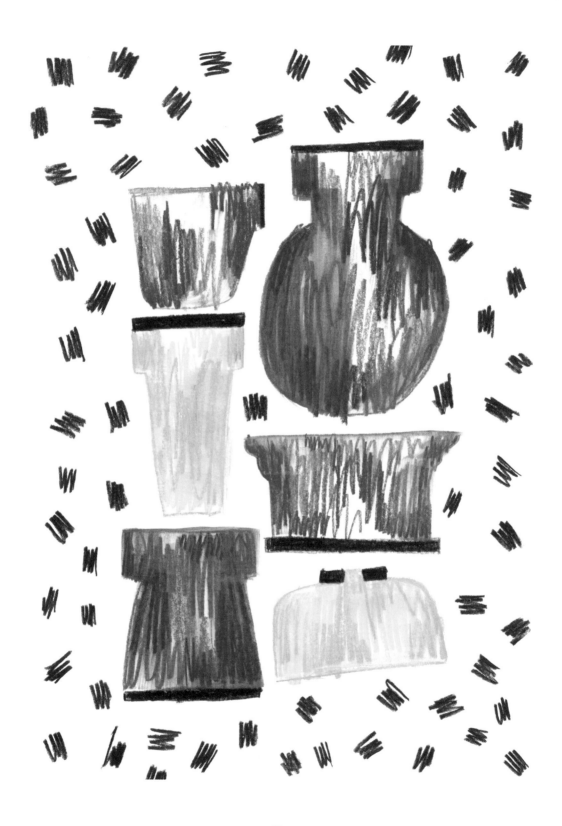

DRAW
HERE

For this experiment, the only restriction is color. Try focusing on the primary ones—red, yellow, and blue. You can also add a bit of black for good luck! Feel free to blend them and apply these blended hues between the primary colors and see what other colors you come up with. There are so many possibilities!

TIP: IN THIS EXERCISE, APPLY A LITTLE WATER WITH A BRUSH TO SOME AREAS OF THE DRAWING TO BRIGHTEN AND ENRICH THE SHADES. REMEMBER THAT JUST A BIT OF WATER WILL GO A LONG WAY.

PLAID AND WEAVING

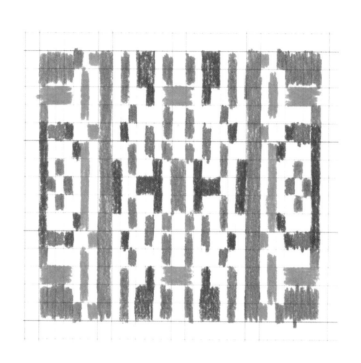

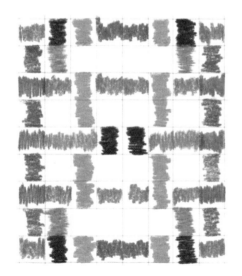

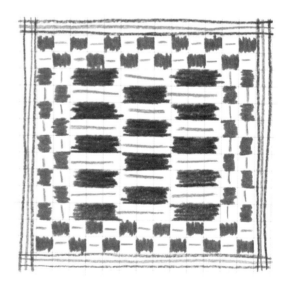

Pick a grid paper or make a grid on a plain piece of paper yourself. Start coloring different areas of the grid as if you were planning a weaving for a fabric or a rug. You can do a simple interweave design or try something more complex with different motifs.

TIP: EXPLORE DIFFERENT MATRIX SHAPES IF YOU MAKE THE GRID YOURSELF. NOT ALL GRIDS HAVE TO BE RECTANGULAR. YOURS COULD BE TRIANGULAR, LIKE THE ONES IN GEODESIC DOMES, OR ANY OTHER SHAPE, REALLY!

VANISHING POINT

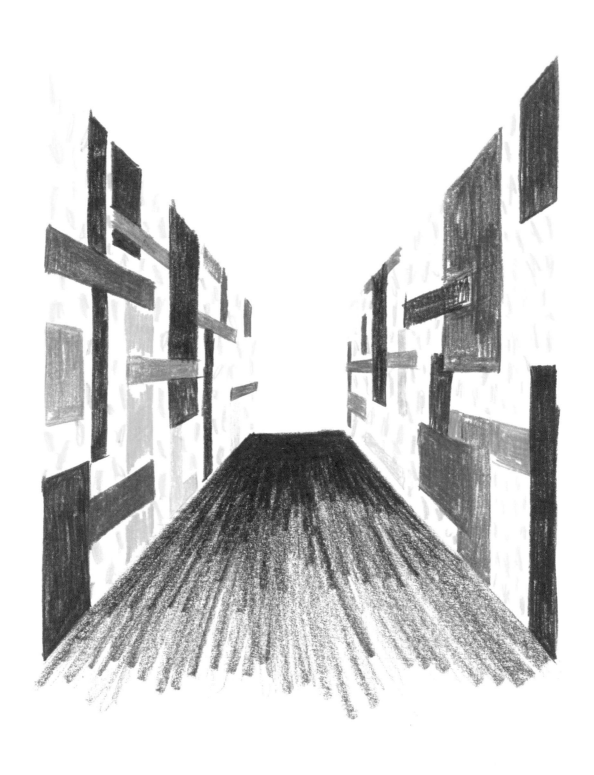

Choose a point in the center of the paper. This will be your vanishing point. All the lines that are not vertical in your drawing need to go toward this point for the optical effect to fully work. Use a ruler to help you outline your drawing. After coloring, you can erase all the pencil structure that helped originally with the construction.

TIP: YOU CAN ALSO USE COLORS TO PLAY WITH DEPTH AND HELP YOUR PERSPECTIVE WORK EVEN BETTER. THE HUMAN EYE NATURALLY PERCEIVES WARMER HUES AS CLOSER THAN COLDER SHADES, WHICH TEND TO RECEDE.

COLLAGE AND DRAWING

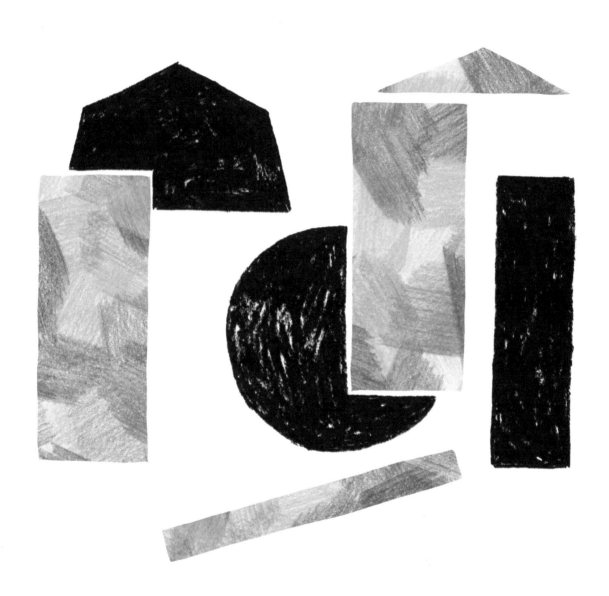

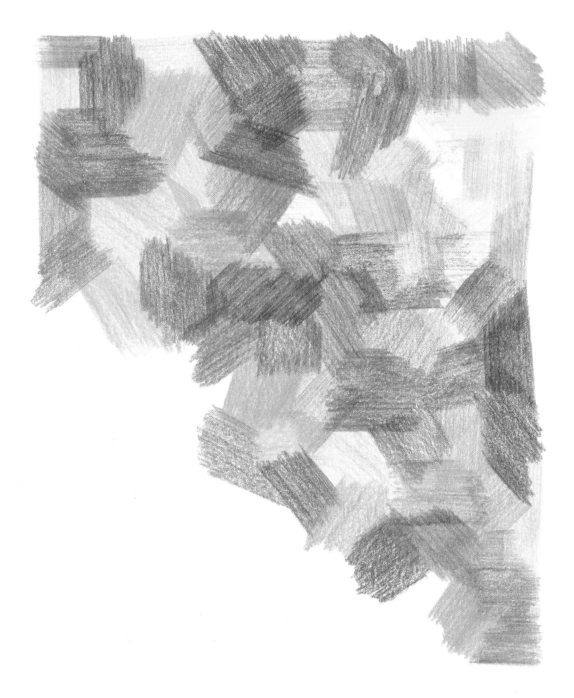

Softly apply different colors overlapping each other a bit. Cover a big area of the paper, as shown above. Use as many hues as you want. Cut pieces out of the paper and arrange and glue them on a different sheet of paper. Now draw around the collage. Try charcoal, but feel free to use any other tool or technique.

TIP: FOR COLLAGE WORK, ALWAYS TRY USING NONTOXIC GLUE. COCCOINA, FOR EXAMPLE, IS MADE FROM POTATO STARCH AND HAS A LOVELY ALMOND SCENT.

THE OTHER HAND

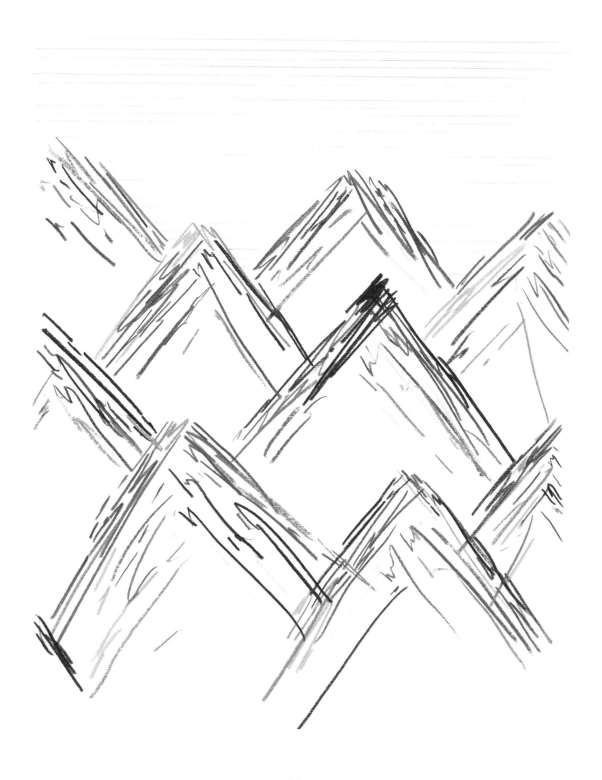

DRAW HERE

Challenge all the perfect landscape representations out there and try drawing a mountain chain—or something similar—like a child would. Play with abstraction, broken strokes, unexpected colors, and so on. Connect with your inner child and have fun!

TIP: TRY DRAWING WITH THE HAND YOU DON'T NORMALLY USE TO WRITE WITH FOR YOUR STROKES TO BE MORE RANDOM AND SPONTANEOUS.

UPSIDE DOWN

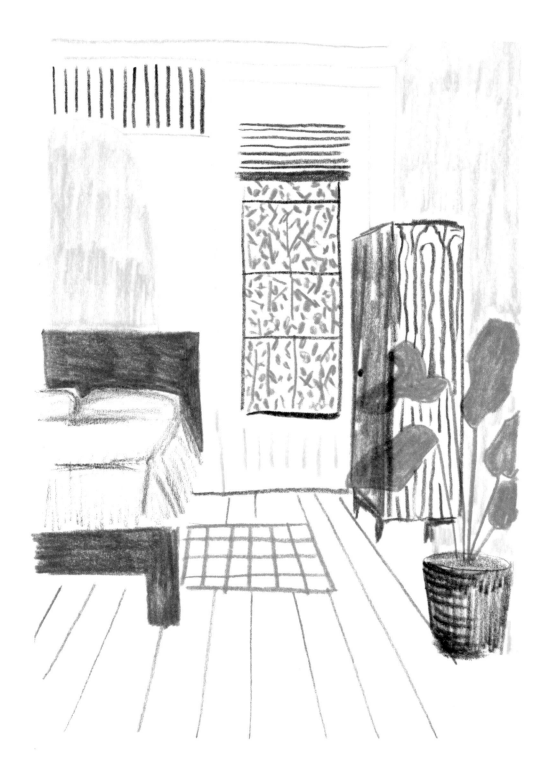

DRAW HERE

When we are looking at a reference image to draw, our brain doesn't stop identifying the objects in the picture. Turning the image upside down will help you concentrate solely on the shapes and contours without analyzing too much, and your drawing will be more accurate to the original.

TIP: PLACING THE REFERENCE IMAGE UPSIDE DOWN HELPS BUT IF YOU WANT EXTRA HELP, YOU CAN ALWAYS DRAW A GRID ON TOP OF THE IMAGE AND FOCUS ONLY ON ONE AREA OF THE GRID AT A TIME.

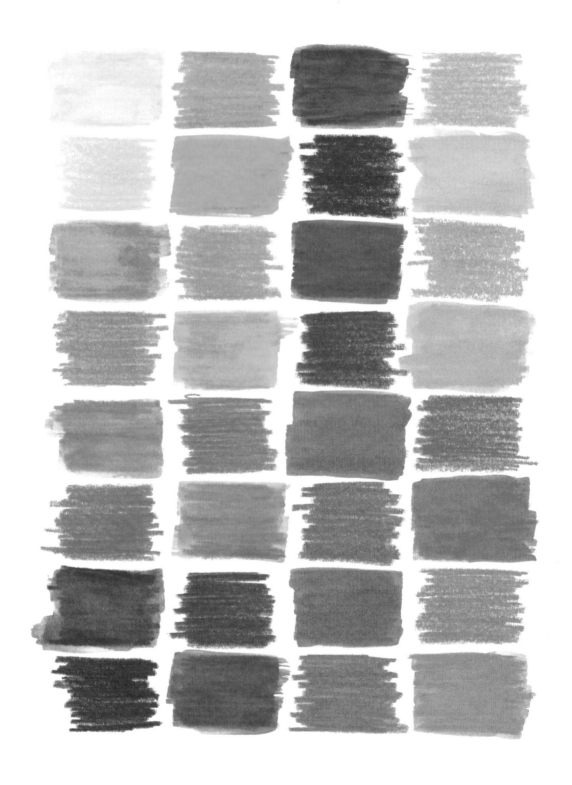

DRAW HERE

Water-soluble pencils are more versatile than the average graphite pencil. Apply different colors to a piece of paper, add a few touches of water, and the colors will magically become brighter and smoother. Make a palette with your pencils to see how they change from dry to wet.

TIP: YOU DON'T NEED TO APPLY A LOT OF WATER WITH YOUR BRUSH. JUST DIP THE TIP AND CAREFULLY PASS IT OVER THE SURFACE YOU WANT TO BLEND. ADD THE NAMES OF THE COLORS TO YOUR CHART TO KNOW WHICH IS WHICH.

FLOWERS

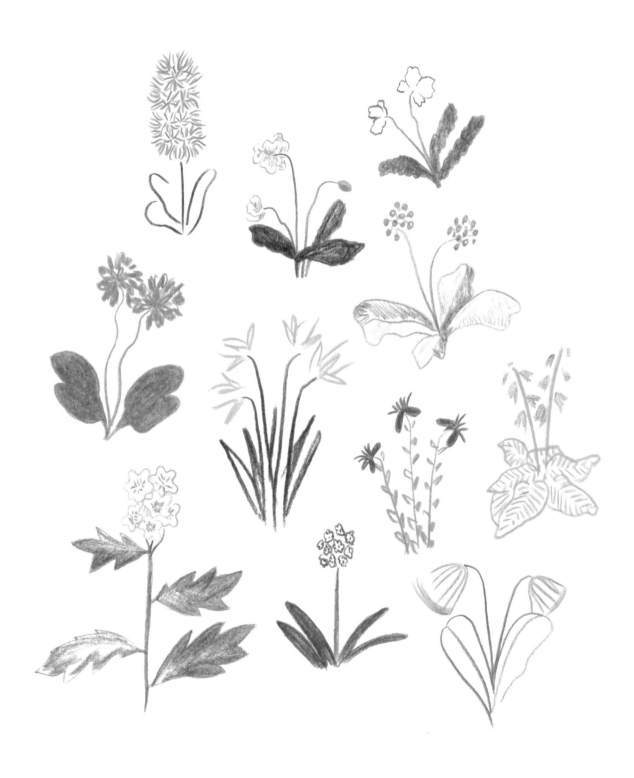

Focusing your attention on a subject while drawing helps you better understand its shape. Try sketching a range of flowers and notice the differences and similarities among them. You don't need to be too accurate, just play around with your pencil.

TIP: IF YOU KEEP ON SKETCHING MANY LITTLE FLOWERS ON THE SAME PAPER, YOU'LL GET AN ALL-OVER PATTERN! WHEN DOING THIS, TRY DISTRIBUTING THE COLORS AND SHAPES EVENLY FOR A BALANCED COMPOSITION.

A TOUCH OF WATER

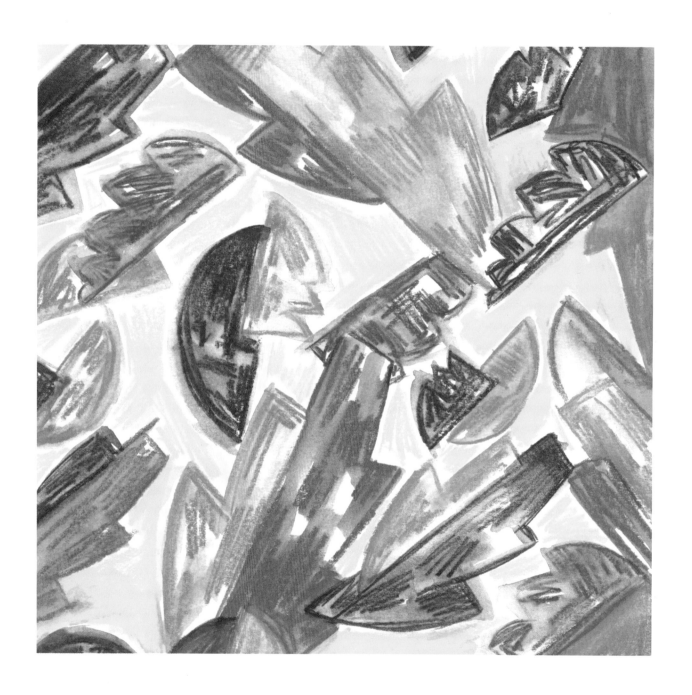

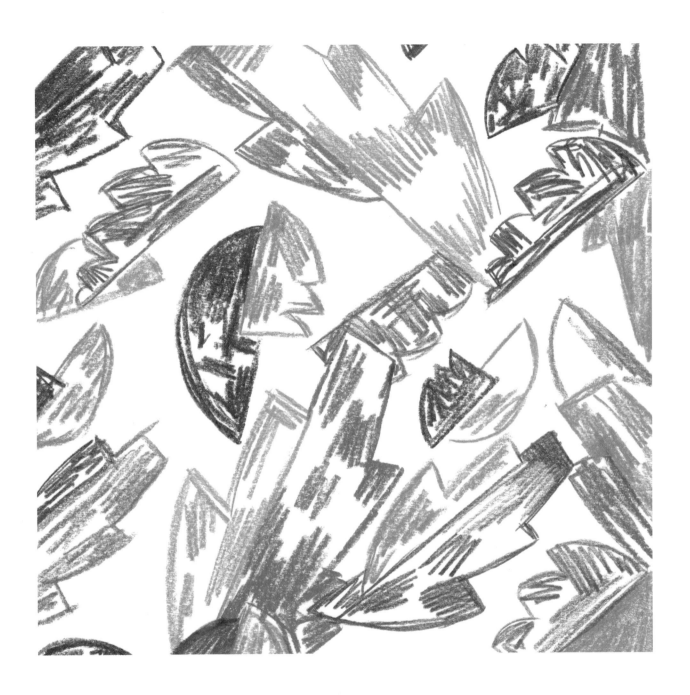

Achieve a painterly look by applying some water to watersoluble pencils. Sketch the artwork with watersoluble pencils instead of graphite or charcoal so that all areas of the artwork become smooth and fluid.

TIP: DON'T OVERDO USING THE WATER AND BRUSH. LEAVING SOME PENCIL MARKS CAN GIVE YOUR DRAWING AN INTERESTING TEXTURE AND A CLUE ABOUT ITS ORIGINS.

ZIGZAG

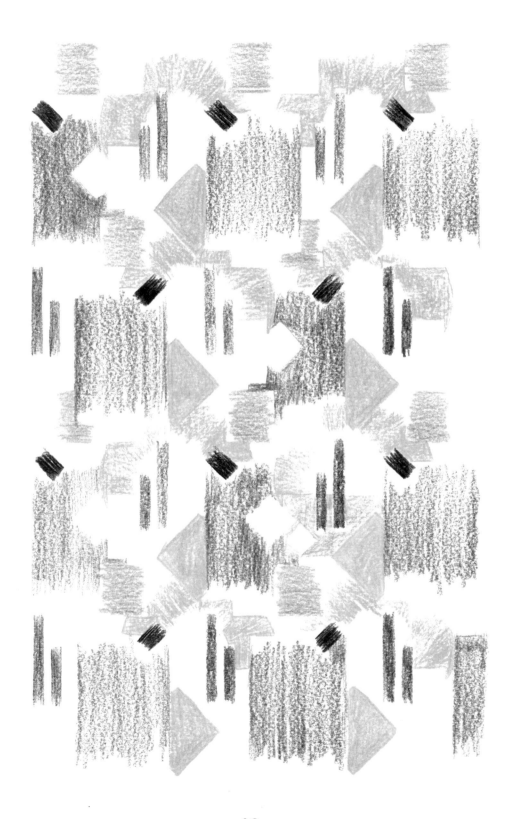

This composition was done repeating the same motif while rotating it 180 degrees. Outline a grid on the paper to help you position each repeat/motif. There's no need to be too accurate, really. The pattern can be as organic and freestyle as you wish!

TIP: FEEL FREE TO PLAY WITH NEGATIVE (BLANK) SPACE. DON'T FEEL FORCED TO FILL IN EVERYTHING WITH COLOR. IN THIS DRAWING, FOR EXAMPLE, I LEFT SOME AREAS WHITE TO ACHIEVE A FRESH, "UNFINISHED" LOOK.

COLOR INTERACTION

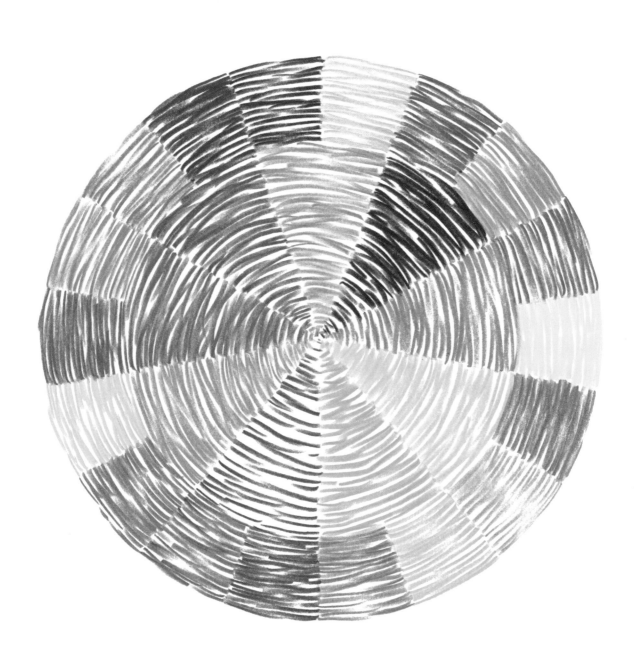

Color interaction is complex but fun. There are lots of books and theories about the subject, but the best way to understand it is to experiment with it. Make a wheel and start coloring its different areas. Notice how the colors behave when they are placed side by side or when they are opposite one another, for example.

TIP: THERE'S A VERY GOOD BOOK BY THE ARTIST JOSEF ALBERS ABOUT THIS SUBJECT. IT'S CALLED *INTERACTION OF COLOR.* CHECK IT OUT TO LEARN ABOUT A WIDE RANGE OF COLOR PERCEPTION EXPERIMENTS.

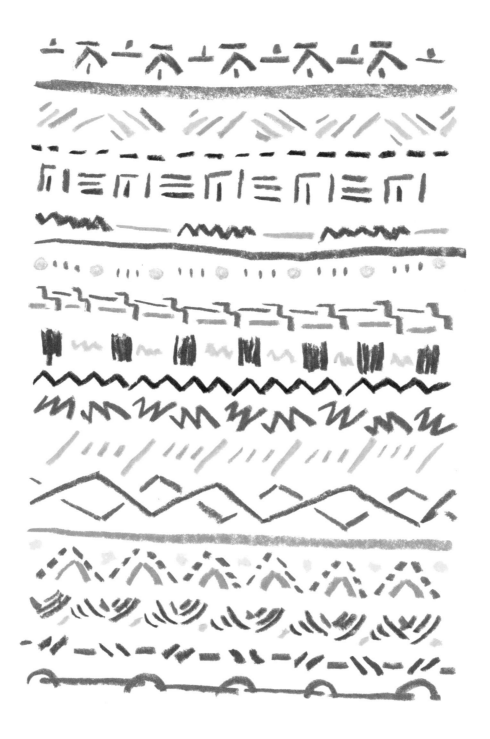

DRAW HERE

Oil pastels are great for making thick marks and bold shapes. Their creamy texture makes them easy to work with. For this exercise, try making party garlands using different colors. They can be geometric, floral, or typographic—it depends on your party!

TIP: HEAT THE TIP OF A WAX PASTEL VERY GENTLY ABOVE THE FLAME OF A CANDLE FOR JUST A SECOND BEFORE YOU DRAW EACH TIME. THE SOFTENED PAINT CAN BE BUILT UP FOR A 3-D EFFECT OR EXTENDED AND BLENDED.

ZEN DOTS

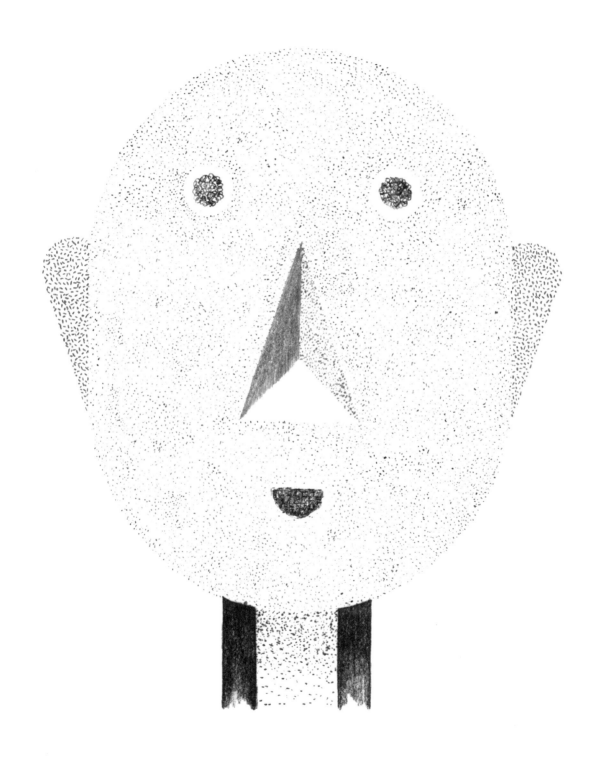

DRAW HERE

This kind of drawing takes time, but it's meditation in its purest state. Just repeat a mantra or focus on your breath every time you make a new dot and clear your mind of thoughts. It's fun to see the image surfacing among the textures.

TIP: IF YOU DON'T WANT OUTLINES ON THIS EXERCISE, MAKE YOUR SKETCH ON A PIECE OF PAPER AND THEN PLACE CARTRIDGE PAPER ON TOP OF IT AND A LIGHT BELOW. THIS WAY, YOU CAN FOCUS ON ADDING TEXTURE TO THE AREAS.

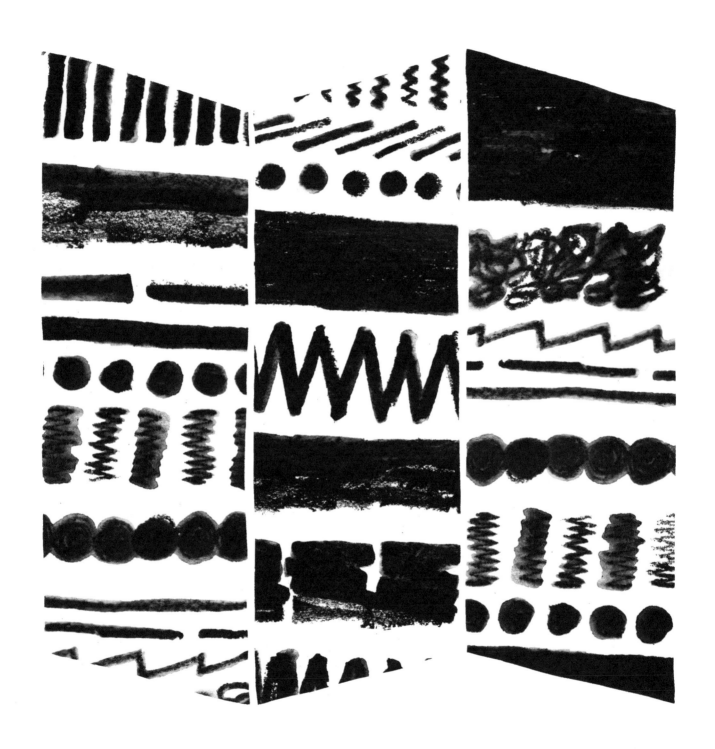

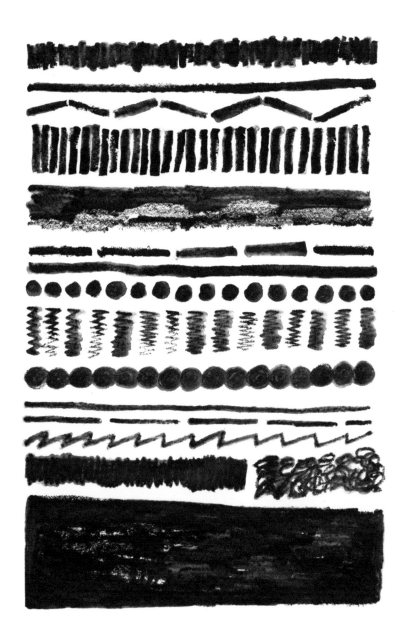

For this exercise, draw textures on different papers and then cut, arrange, and glue them to make the screen (room divider) shape. Make the lines by dipping a water-soluble graphite pencil in water. This way, the marks have a more fluid look and deeper tone. For a sharper look, you can use charcoal instead of water graphite.

TIP: IF YOU OPT FOR CHARCOAL, BEWARE AS IT CAN BE VERY MESSY. LUCKILY, BRANDS SUCH AS CONTÉ CHARCOAL PENCILS EXIST TO KEEP OUR HANDS CLEAN WHILE DRAWING AND ARE MORE ACCURATE THAN CHARCOAL STICKS.

CROSS-HATCHING

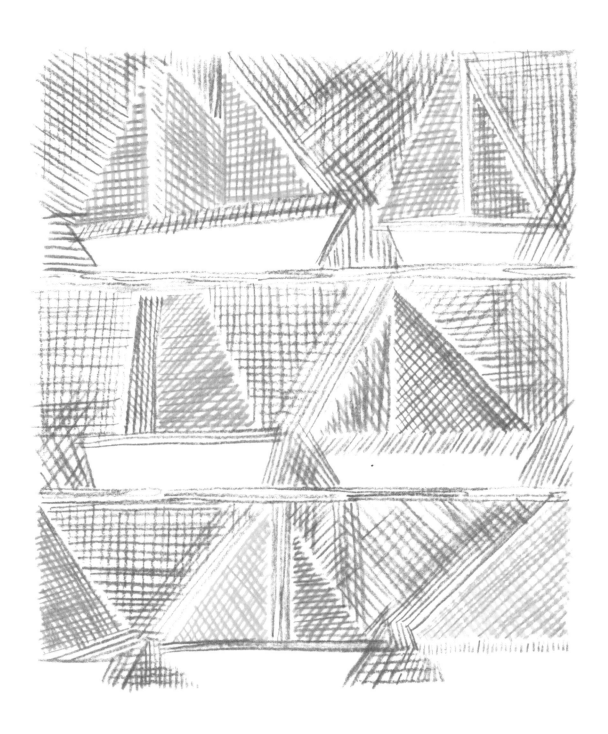

DRAW HERE

Outline the composition with a mechanical pencil and ruler. Crosshatch the textures in different directions to give the artwork more movement. Try marks crossing at different angles to differentiate the areas. Carefully erase the pencil marks.

TIP: YOU CAN CROSSHATCH USING THE SAME COLOR PENCIL OR MORE THAN ONE IN SIMILAR TONES. IF YOU ARE LOOKING FOR CONTRAST, YOU CAN ALSO USE COMPLEMENTARY COLORS.

PLEIN AIR

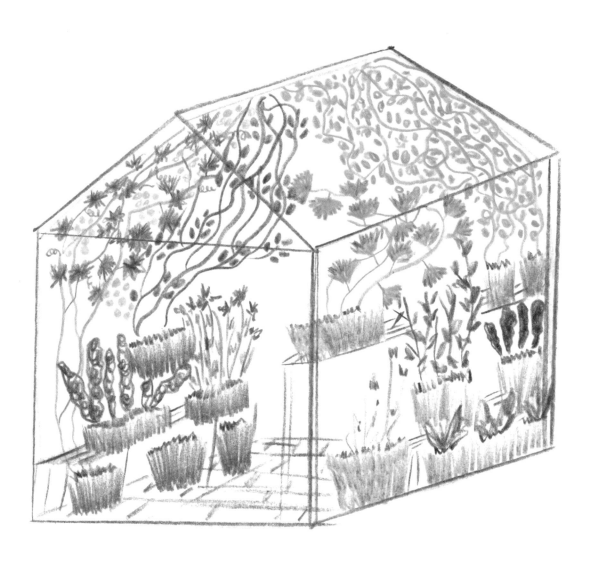

DRAW HERE

Sketching outdoors is fun and can feel like an adventure. Go for a walk with your notebook and pencils and start drawing something that captures your attention. Here, I drew my greenhouse, picturing the plants in a free and loose way. The various green shades and recognizable greenhouse shape bring a realistic quality to this sketch, despite the abstract greenery.

TIP: TO GIVE A MORE COMPLEX ATMOSPHERE TO THIS EXERCISE, APPLY A FEW PALE COLORS TO DIFFERENT AREAS WITH WATER-SOLUBLE PENCILS AND DILUTE THEM WITH A BRUSH. LET THEM DRY AND DRAW ON TOP OF THAT BACKGROUND.

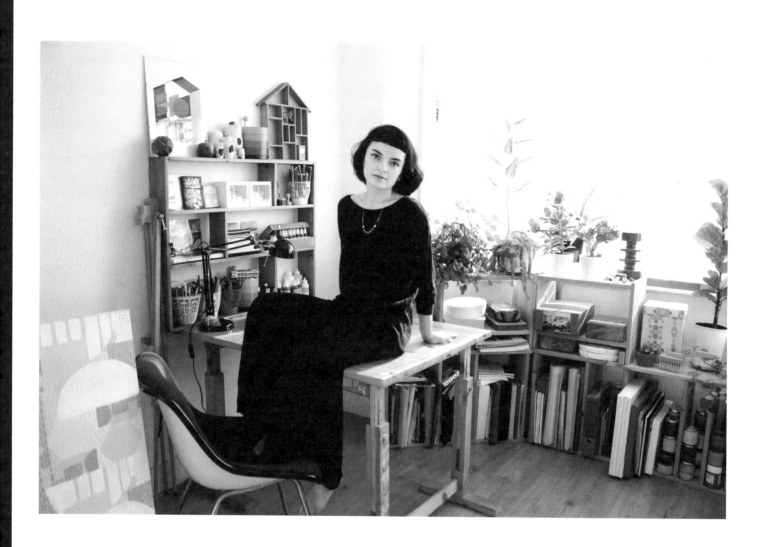

ABOUT THE ARTIST

Ana Montiel is a London-based Spanish visual artist and designer. She works with a wide range of materials and media, from screen printing to ceramics, surface design, installation, and collage. Her influences are as diverse as David Lynch and his holistic approach to creativity, Carl Jung's *Red Book*, vintage educational charts, the arts and crafts movement, astrology, and ayurveda.

Ana also works as an illustrator, art director, and designer and has collaborated with the likes of John Legend, Nina Ricci, Jo Malone, Carolina Herrera, and Anthropologie.

She has her own wallpaper line, the first design of which was selected as a "key product to watch" in the *New York Times*.

Her artwork has exhibited in Europe and North America, and she has been featured in international digital and print media such as *Grand Designs*, *Elle Interiör*, and *El País*.

Quarto is the authority on a wide range of topics.

Quarto educates, entertains and enriches the lives of our readers—enthusiasts and lovers of hands-on living.

www.QuartoKnows.com

First published in the United States of America in 2015 by
Quarry Books, a member of
Quarto Publishing Group USA Inc.
100 Cummings Center
Suite 406-L
Beverly, Massachusetts 01915-6101
Telephone: (978) 282-9590
Fax: (978) 283-2742
www.QuartoKnows.com
Visit our blogs at www.QuartoKnows.com

10 9 8 7 6 5 4 3

ISBN: 978-1-63159-046-7

Digital edition published in 2015
eISBN: 978-1-62788-339-9

Library of Congress Cataloging-in-Publication Data available.

Cover and design: Ana Montiel and Tea Time Studio

Printed in China